Graphic design: Janne Vesterinen

Photographs if not stated otherwise: Jari Jetsonen

Pictures editor: Jari Jetsonen

Translation: Maija Kärkkäinen

Checking of the translation: Michael Wynne-Ellis

© Jari Jetsonen and Building Information Ltd 2003

In cooperation with Museum of Finnish Architecture

Publishing company: Building Information Ltd
www.rakennustieto.fi

ISBN 951-682-731-4

Paper: Mango Satin 150 g

Printers: Tammer-Paino Oy, Tampere, 2003

RAKENNUSTIETO®

Sacral Space

MODERN FINNISH CHURCHES

PHOTOS JARI JETSONEN | TEXTS SIRKKALIISA JETSONEN

CONTENTS

Foreford 5
Severi Blomstedt

Sacral Space – at the Roots of Modern Finnish Church Architecture 6
Sirkkaliisa Jetsonen

The Beauty of Hidden Order 10
Fred Thompson

The Resurrection Chapel 14
Erik Bryggman

Otaniemi Chapel 30
Kaija ja Heikki Siren

The Church of the Three Crosses 38
Alvar Aalto

Vatiala Chapel 50
Viljo Revell

Hyvinkää Church 58
Aarno Ruusuvuori

Kaleva Church 66
Raili and Reima Pietilä

Temppeliaukio Church 76
Timo and Tuomo Suomalainen

The Chapel of the Holy Cross 86
Pekka Pitkänen

Olari Church 98
Käpy and Simo Paavilainen

Kauniainen Church 106
Kristian Gullichsen

St. John's Church Männistö 118
Juha Leiviskä

St. Henry's Ecumenical Chapel 130
Matti Sanaksenaho

Selected Information 136

FOREWORD

Modern Finnish church architecture is a unique phenomenon. Comparison is hard to find elsewhere in the world in quantity as well as quality. Churches were built in exceptional numbers after the second world war. Most modern churches have been built as the result of architectural competitions and thus represent the very best of their time. In addition to prominent architects, a large number of remarkable Finnish artists and designers have contributed to the interiors, lighting, textiles, articles and paintings of churches.

Out of a total of approximately 200 post-war churches, the book *Sacral Space* presents twelve representing different decades and different kinds of chapels and churches. In the Lutheran church service, preaching and hearing the Word play the leading role. The most central place in the east-west oriented church is the altar and the pulpit. In a funeral chapel the essential feature is the feeling of the sequence of spaces, which frame the funeral procession.

In a church, architectural vocabulary is at its most delicate. In modern Finnish churches, the subtle interaction of light and space is the most characteristic feature. Another powerfully conveyed theme is the feeling of nature. These characteristics, instead of ornamentation, generate the pure atmosphere of today's Finnish church. Unpretentiousness has its origins deep in the past and national character.

Severi Blomstedt
Director, Museum of Finnish Architecture

Sirkkaliisa Jetsonen

SACRAL SPACE | AT THE ROOTS OF MODERN FINNISH CHURCH ARCHITECTURE

THE FINNISH TRADITION

The oldest preserved heritage in Finnish church building consists of the medieval stone churches dating from the 13th to 16th centuries and originally used for Catholic services. The construction of a church was a huge joint effort on the part of a parish. Often placed to dominate the landscape, Finnish grey stone churches are characterised by high gables with brick decorations and steep roofs. In the interior, Biblical stories depicted in wall paintings, the warm light of candles, the fragrance of incense and the thunder of the mass addressed the illiterate parishioners. A church was something totally different from the greyness and deprivations of ordinary life.

The Reformation severed the connection to the international Catholic Church, and in the 17th and 18th centuries the stone churches were followed by a rich tradition of wooden churches built by vernacular master builders. A deeply Finnish sacral space evolved. The impressiveness of these buildings, modest in their materials, is due to the devotion put to their building year after year. Their harmony, honest sensitivity, balance of light and space, still speak to today's visitor.

Finnish Lutheran churches have a distinct spatial organisation. The rectangular oblong church, often provided with a west tower, has alternated with the cruciform church that is related to the international tradition of the centralised church. The cruciform type blossomed especially in the 18th century, while the oblong type established its popularity in the following century. Church architecture followed general stylistic developments, and the late 19th century was dominated by the neo-Gothic and neo-Renaissance. The National Romanticism of the turn of the 20th century, inspired by the Middle Ages, went back to the feeling of the grey stone churches.

The 1920s were a period of active church design and construction. Inspiration was sought in historical architecture and, for instance, Italian village churches. The architectural expression in churches varied from light classicism to symmetry and even monumentalism.

In the 1930s the reduced forms of functionalism made their appearance in entries to church design competitions; former churchy ornamentation was replaced by the simple, unpretentious language of form. Architects and churchmen entered into a vivid discussion on whether or not a church can be modern. Traditionalists appealed to a tradition refined over the centuries, while the modernists aimed at freedom from obsolete forms. The idea that a church should have a dignified and uplifting overall expression, the label of a sanctuary, was expressed in a sentence often repeated in the discussion: A church must look like a church. Since the 1930s churches included more parochial meeting rooms than before, which changed the character of the buildings to some extent.

ASPECTS OF MODERN CHURCH ARCHITECTURE

During the second world war churches in Finland, among other buildings, began to be reconstructed. At that time competition entries often showed efforts to combine the traditional, medievalist, high-pitched church 'to an otherwise modern design'. Presumably medieval themes were so distant that architects could accept them and others could acknowledge their traditionality. In the historical post-war circumstances, a symbol perceived as Finnish combined with a precise form met many demands. The church also played an important role as a mental connector.

Landscape has always been an essential element in the selection of a site for a Finnish church. It is a long way from the landmarks of the Middle Ages to the park-like churchyards of the 19th century. Wartime brought a new dimension: in war cemeteries the connection of nature, as well as landscape, to sacral building was much closer.

Besides the nature dimension, another topical issue in the 1950s was the development of a city church. The aim was to make the church more active and open and bring it closer to people. New churches were needed, especially in the rapidly growing suburbs. The content and form of a church were topics of lively debate. Churchyards and squares made the building a part of the urban structure. Monumentality gave way to 'activity centres'. As part of the social reform movement, the church was linked to more secular club and hobby activities. On the other hand, the tradition of monumentalism was still alive in competitions for churches for Lahti and Seinäjoki. Alvar Aalto's successful entries are impressive expressions of the possibilities of monumentalism in modern church architecture.

A large number of church competitions were organised in the 1950s. Especially towards the end of the decade, entries introduced new spatial arrangements and new kinds of floor plans: triangles, circles and ellipsoids were considered interesting modern alternatives alongside the traditional oblong church. Industrialised building methods and concrete shell structures had an influence on architectural expression. Geometric designs taken to extremes sometimes approached formalism and were totally detached from their site. Photographs of

< *The Church of the Holy Cross, Hattula, from the late 14th to the early 15th century.*
∧ *Erkki Huttunen, Nakkila Church, 1936–37.*
∨ *Petäjävesi Church, 1763–65.*

> *Balthasar Neumann, Benedictine Church, Neresheim 1747.*
∨ *Le Corbusier: The Chapel of Ronchamp, 1950–55.*
∨ *Oscar Niemeyer, The Church of Saint Francis of Assisi, Pampulha, 1943.*

the Chapel of Ronchamp by Le Corbusier and the Pampulha church by Oscar Niemeyer in Brazil were familiar also to Finnish architects and likely to inspire them to experiment with free form.

Opposition to individuality and monumentality arose in the 1960s. In place of them, there was a demand for intimate small churches where one could compose oneself and withdraw from everyday bustle. The architecture of the churches of this period favoured constructivist themes, such as steel structures. On the other hand, the church building was reduced to the extreme; the austerity of fair-face cast concrete approached the spirit of classicism.

During the last decades of the 20th century churches have acquired ever more varying forms. The activities of the church have became more versatile requiring flexibility. Many of the newest churches have forms and details that consciously refer to history or the tradition of Finnish modernism. Another feature in recent churches is that they aim to create the framework for a powerful experience. Contemporary churches often offer a possibility of withdrawing from the commotion of the surrounding world. Modern Finnish church architecture can perhaps be seen to have as a thoroughgoing principle the parallelism of religious and constructivist thought. In a sacral building architectural vocabulary is at its most delicate. The most characteristic feature of modern Finnish churches is the subtle interaction of light and space. Another powerfully conveyed theme is the feeling of nature. These characteristics, instead of ornamentation, generate the pure atmosphere of modern Finnish church.

HOLINESS AND ITS EXPERIENCING

A holy place has always been distinct from the ordinary sphere of life. In natural religions mountains, uniquely shaped rocks, stones or trees have been considered holy or have symbolised holiness. They have been revered, even feared, and people have made offerings to them. By marking a place, man has drawn a line between holiness and everyday. The sphere of a holy place has been left in peace; it has only been approached when necessary.

Holiness is one of the essential qualities of human life. It has been seen to represent an organised reality alongside the chaos of life. The emotions: fear, power, energy, incomprehension, attraction, immenseness and humility are the qualities associated with holiness. Experiencing it is at once mystic, fascinating and awesome. Within it individual experience encounters universality. It embodies the possibility of being in contact with the other world beyond the mundane everyday life. Architecture, even as organised reality, can be the fabric of holy experience, if only the qualities touching the emotions are present in the space.

A church is a symbol, the external frame of holiness. The medieval cathedral was a gateway to heaven. Through their rhetoric, baroque churches aimed at

convincing people of the supremacy of the church. Theological interpretations have had their effects in architecture: the bringing of mystic darkness and heavenly light into a space narrates the ideas of the time. A church is a concrete space, but simultaneously part of another reality.

In the Protestant Church, congregational community with its internal structure, and adoration, the holy reverence, have long been the principal elements of the divine service. A church interior may enhance adoration and in a way elevate the congregation before God. The choir and the altar within it are the symbols of prayer and worship. Assembling together to hear the sermon, has had an important part in congregational structuring.

The Protestant Church is a church of the word, traditionally based on hearing rather than seeing. The Catholic and Orthodox Churches on the contrary have traditions involving holistic, recurring rituals. In them, the experience is gained through many senses: light, sound, odour, even the warmth of candles speaks to the congregation. The Lutheran service and church are characterised by reduction, instruction and rationality. There is not much moving about during a Lutheran church service.

Traditionally, the various parts of the church have different degrees of holiness. The most central place is the choir and the altar. The east is the direction of God. Towards the west the church forms a wall against evil forces. A church interior can also be interpreted as a holy route, in which the west door is the border of the world and along which one proceeds towards the choir wall with eternity waiting beyond. A church building also provides a temporal north-south reading, from the Creation to the Last Judgement. Church ceremonies have been assigned different places at different times: baptism, for instance, was once performed near the entrance, for it was a 'gateway' to church membership.

A church building can also reveal the symbolism it embodies. The symbol continues where the word ends. Even the eyes can hear. Holy silence is a speaking and creative quietness. In a funeral chapel, atmosphere and the procession route, the sequence of spaces walked through, play a part in supporting mourners in their moment of grief.

Fred Thompson

THE BEAUTY OF HIDDEN ORDER

Standing on the market square in Helsinki, one can see the Lutheran Cathedral looming up behind the City Hall. To the left, across a narrow body of water, lies the Russian Orthodox Uspensky Cathedral, a reminder that here East meets West. The Uspensky Cathedral, with its red brick, undulating forms and smell of incense, stands in stark contrast to the Classical discipline of the Lutheran Cathedral, almost as a statement of defiance.

Both cathedrals are monumental in their forms, reminders of the history of Finland. In a country once ruled by the Swedes, and then by the Russians, religious feelings became mixed with political intentions and many of the social concerns of the churches in Finland reveal a difference in their forms from many of the churches of Southern Europe. Our first impulse is to look at the monumental, the spectacular. But with time we realize we are looking at only half the picture. The other half consists of the chapels, offices, meeting rooms and places for social support that is offered through the church. Such spaces, although not as moving as the church proper, are carried out with equal care and concern, which is a hallmark of "the culture of architecture."

One of the most significant examples is the Resurrection Chapel by Erik Bryggman, built between 1938 and 1941. To me, it takes its cues from Sigurd Lewerentz's Chapel of the Resurrection in Stockholm, Sweden begun some 13 years before Bryggman's. Lewerentz had been moved by the plight of rural migrants to the cities, and in particular by the special troubles they faced when one of their number died. These newcomers felt uncomfortable coping with death in the great monumental churches of the inner cities; they would have preferred humbler surroundings. The new population also placed too great a burden on the cities' limited burial places, and it was clear that space would be needed for burial outside the urban centres. In his Turku Resurrection Chapel Bryggman seemingly opted for a solution similar to Lewerentz's embodying a movement from a Hall of Death to a Hall of Life.[1]

The mourners move up a path to the chapel, through the heavy façade to the glass doors with beautiful wrought-iron grille work. Through the glass, one can glimpse the light that opens up the nave of the chapel. After passing through the vestibule, with its low ceiling reminiscent of the entrance into the main room of a Karelian house, the mourners enter the high-vaulted, light-filled nave. The pews are racked out at an angle towards two points of focus: the altar, and a low alcove wall of glass that reveals the surrounding forest. After the service, the mourners move forward to the door, to the right of the chancel and out into the forest, the space of recuperation, the Hall of Life.

Though the chapel is called the Hall of Death, to walk through it is a reflective rather than a depressing experience. My first impressions of this chapel, in 1955, drew me to return as often as possible, as a sort of pilgrimage. It was only in the 1980s, when I began to study Lewerentz's work, that another layer of meaning and delight made its way into my appreciation of Bryggman's work. It is less intellectual and far more

<< *C. L. Engel, Cathedral, Helsinki 1852.*

< *Aleksei Gornostajev, Uspenski Cathedral, Helsinki 1868.*

moving, in my opinion, than Lewerentz's chapel. It truly calms the body and soul, allowing the eye to search out details on which to rest and meditate. The geometry is pure, the columns to the right of the nave strike the overhanging ceiling with the precision of a watch maker, the windows regulate nature, which "is not cruel, only pitilessly indifferent."[2] The artificial illumination is designed for the occasion and the vines climbing the wall behind the altar reflect the vines in the grille work of the entrance doors. Nothing is left to chance, all elements contribute to a forward movement. In its uniqueness, this chapel sets the stage for much of what was to follow in church architecture of twentieth-century Finland.

Heikki and Kaija Siren's chapel at the University of Technology in Otaniemi was yet another encounter with nature. This time, in an apparently dry, technological approach, the almost Miesian box is given life and warmth within the strictest of parameters. And yet, as in Bryggman's chapel, the geometrical symmetry of the box is offset by the asymmetry of the approach. Ritual and space have worked to accept the imperfection of nature as a given part of the religious background upon which Lutherans had built their doctrine.

In Bryggman's chapel, one moves into the space up a wide side aisle to the altar with seating to the left and the low ceiling window to the right, a gallery for the flowers of remembrance. In the Sirens' chapel, one moves through a low-ceilinged space along the right-hand wall towards the nave of the chapel, through the area for social gatherings, and finally to the altar. Behind it, a glass wall reveals a steel cross of strict proportions planted in the forest beyond. The cross is out in the cold, so to speak, but the viewer's reaction is to pull it in. The asymmetry of the room is a symbolic reaction to the architecture of power, which is usually based on symmetry. An architecture that empowers is one in which figure and ground play on each other to probe the participants' sense of values.

The strictness of the brick details and the iron work of altar, altar rails and lectern are set off against magnificent wooden trusses that allow the sun's light to cast shadows over the congregation as it looks out to the cross through the glass wall, a wall of light. Nature is omnipresent, both natural and man made.

From 1964 to 1968 I worked in the office of Professor Aarno Ruusuvuori. The Hyvinkää church had been completed and the Tapiola church was under construction. For a short time I was a part of the culture of the latter church. Probably one of the most memorable comments made by Ruusuvuori about one of my details on a separate building was, "You should try again because it looks 'designed'." A very sobering comment, yet one that bears reflection. For isn't it true that an architect is like an accountant in some ways? He must reckon with emotion and with calculation about architecture as a reflective surface for the eye of the beholder.

It was at the end of our sojourn in Finland that we went to see the newly completed Kaleva Church by Raili and Reima Pietilä in Tampere. That was a shock to

the system. Such curvature and movement exceeded my disciplined background, yet they absorbed my curiosity and eventually gained my respect.

Here was an expression of nature bound up in the architects' psyche, which played itself out in an acoustical form, or even an acoustic form in McLuhan's sense of the word: the tactility of the building caused the eye to caress the forms as they moved upwards to the wooden ceiling with its almost erotic undulations. In plan, one can say that there is a symmetrical axis but this symmetry is offset by the curvature of the walls. The whole gives the sense of a box of sound and light whose centre is nowhere and whose circumference is everywhere. The altar is present and all the trappings of the Lutheran liturgy are present but they are subsumed in the natural setting of the architecture. The sense of a space in support of propaganda is replaced by a sense of harmony with nature. Going up to the top of the tower is a way of taking in the space as a whole and realizing how important the human scale is to the effect of the whole.

Another way to experience the building is to hear it. On one occasion when I had taken a group of students to "see" the church, and a student played a Chinese block flute from the choir stalls. He played the instrument without stress, almost as though he were whispering into the instrument, and yet it filled the whole building with beauty.

And finally I shall move on to Pekka Pitkänen's church in Turku, not far from Erik Bryggman's Resurrection Chapel. Here the accounting is complete. The stark reality of minimal moves brings one to a standstill. In a play of proportions, light and movement, nature is captured in small epic-like courtyards seen to the side through glass walls. In a way they are reminiscent of the dry gardens of the Japanese, in which nature is disciplined only to borrow from the larger picture in the distance. The effect of nature captured for the benefit of relief makes the whole even more startling. And here I invoke Joseph's Brodsky's statement, "when a man's alone, he's in the future"[3] The walls are washed with light and yet appear almost as a wailing wall, a wall to touch so that one can realize the warmth one can give. The walls are of concrete: bare and hard, with the vague smell of mildew, and yet like wood they have a life of their own, albeit at a slower pulse. The overall effect made me reflect on Helvi Juvonen's poem[4]:

'The Christ Tree'
There was a tree. Every passer by
picked its fingers and took them away.
Its arms were cut off and from the wounds
In its side flowed the juices of life.
And the naked trunk was cut down
For every human being's sake.

<<< *Erik Bryggman, the floor plan of the Resurrection Chapel.*

<< *Sigurd Lewerentz, the floor plan of the Chapel of the Resurrection.*

< *Sigurd Lewerentz, The Chapel of the Resurrection, Stockholm 1925.*

This poem could be a way of reacting to the spaces in Pitkänen's chapel but it can also be seen as a way of "strengthening the experience of the self"[5] And here lies the contradiction. Despair is the greatest sin of Christianity and the challenge to move beyond is evident in all the churches I have mentioned. It is the realization that the influence of nature combined with the talent of the architect is to move forward. A quotation from a student: "What I prize most highly from my experience in Finland is the contagiousness of the spirit of optimism, an atmosphere receptive to exchange, experiment and the break with tradition which I encountered in my four months in this country."[6]

To that I can add from one of my very first experiences of Finland in the 1950s. We were being ferried from Korppoo island in Turku archipelago to the mainland and the men who boarded the cars stopped to talk with us as the ferry set out from land. "Architect, are you? Have you seen Bryggman's chapel in Turku? Aalto's sanatorium in Paimio?" This from ordinary deckhands was extraordinary. Even as a recently graduated architect, albeit brought up on Sigfried Giedion's *Space, Time and Architecture*, I didn't know of more than Alvar Aalto and here I was confronted with architecture as common knowledge.

What started out with the advice from some deckhands led full circle through the history of Finland's culture seen through its monuments in Helsinki and back to the roots which make its churches a viable part of their society. Always questioning the relationship between figure and ground; between what is unseen, seen and otherwise perceived or felt; the shock of discovery. "discontinuity ... more than anything else brings new content, releases locked powers, and opens up the greatest tasks in the realm of life"[7] Such has been the path of discovery from the discontinuity of the two cathedrals seen from the market square: an architecture that is responseable in the form of four – and many more – churches in Finland.

1 I have discussed Lewerentz's solution in an article titled "Heavenward Bound"
2 Richard Dawkins book review on Blind Watchmaker
3 So Forth, p. 64
4 Helvi Juvonen's Poem 'Puukristus'
5 Juhani Pallasmaa, Language of Wood
6 Artia Golestani
7 Harald Høffding, Laws of Media, p. 39

The author wishes to thank Nicole Langlois for her editorial help

TURKU 1939–41

THE RESURRECTION CHAPEL | ERIK BRYGGMAN

The Resurrection Chapel is approached along an avenue of trees in the old part of Turku cemetery. Stone steps ascend a small pine covered hill, on top of which the chapel stands. The overall whiteness of the building gives the feeling of Italian village churches. A campanile rises next to the chapel. The first thing a visitor meets is a closed gable, the rough plaster texture of which reminds one of the unevenness of human life. Time, the years passed are present. The façade is dominated by a golden cross entwined with vines and foliage, its shadow portrayed as a recess in the wall. The vine motif recurs throughout the building. An archaic portico shelters the visitor. Austere bronze doors lead to an anteroom, from which, through glass doors decorated with iron vines, one has a view of the chapel towards the altar, towards the light.

There is a descent of a few steps to the chapel. It is an asymmetrical space with a practically closed wall on the north side, curving as a high vault over the mourners. The wall is ornamented by recessed reliefs with Christian symbols that refer to a deep cultural and historical bond. Besides the reliefs, the wall is decorated by vividly shifting figures formed by light coming from the windows on the opposite side of the vault. The south side of the room is an aisle-like low space whose glass wall opens towards nature, which becomes part of the interior view. Nature is a comforting presence; it evokes hope and calm. The chancel has been separated from the chapel both spatially and by means of lighting. The altar obtains brightness from the rays of light pouring in through a tall side window.

The way out from the chapel is through a stone passage piercing the glass wall. Beyond this symbol of the border between time and eternity one returns to living nature, which during the burial service has been present as an image.

< *The sandstone relief by the main entrance of the chapel was originally designed by Ennu Oka who was killed in the Winter War. His sketch for it is attached to the wall of the entrance hall. The reliefs in the entrance façade and the stone passage were carved by sculptor Jussi Vikainen.*

The brass lighting fixtures by Paavo Tynell are an essential warm-coloured element in the atmosphere of the chapel.

25

< *In the pulpit the vine motif is realised in wood inlay.*

> *An open portico connects the chapel and the mortuary wing.*

Plan 1:600

1 Anteroom
2 Chapel
3 Flower room
4 Relatives' room
5 Mortuary wing
6 Belfry

There was an open competition for the design of a funeral chapel for Turku in 1938, followed by a second stage competition between the best three entrants. The winner was Erik Bryggman with his entry 'Sub specie aeternitatis'. In addition to the chapel and the adjoining rooms for relatives and staff, the building includes a mortuary wing. Construction started in 1939 but ceased for the duration of the Finnish-Russian Winter War. The chapel was completed during the interim peace in 1941.

The exceptional circumstances brought drama to the project: the sculptor selected to make the stone reliefs, Ennu Oka, was killed in the Winter War. Sculptor Jussi Vikainen continued his work.

The curving vault, light softly sweeping the space, views opening through the windows are the essential elements in this delicate spatial composition. Slate stone surfaces and sandstone reliefs complete the light-coloured plastering of the facades. The same materials

Section and facade to south-west 1:600

recur in the interior, where brass light fixtures, wrought iron meanders on the doors and inlaid wood on the pulpit provide a sophisticated enrichment to the atmosphere. The Resurrection Chapel is an unusually delicate building, in which every detail and every material merges into an inseparable part of the total work of art. The architecture has an extraordinary way of allowing space for and giving support to feelings related to a funeral procession.

Perspective view, competition proposal

ESPOO 1956–57, 1978

OTANIEMI CHAPEL | KAIJA AND HEIKKI SIREN

A path leads to the forest chapel from the main street of the Helsinki University of Technology students' housing area. Rowan grows on the front side of the chapel, the holy tree of the Finns. Entrance to the building is through a forecourt. It is a specific delimited space raised a few steps above the surrounding natural terrain. The court, an essential part of the route to the church, prepares the visitor. One approaches the chapel beside a brick wall, as if leaning on it. Flanking the entranceway is a low wooden belfry. The back border of the court is fenced with wooden latticework filtering the view of the forest.

Passage to the chapel is directly through a vestibule occupying one corner of the building. From the door there is at once a view over the chapel to the altar wall of glass, to nature and a cross standing outside. The chapel is dominated by nature, present all the time as a beginning and an end. At the altar wall the view and atmosphere change according to the season and the time of day. The morning sun illuminates the cross from one side. The daytime light strikes it on its front at the same time as light comes in from a window at the back of the church through roof trusses and fills the space with warm tones. Everything here is subservient to nature. The materials of the chapel, red brick and wood in natural colours and a dark, nearly black tone quietly frame it. The pulpit, font and altar rail on the low podium have been reduced to lines in front of the landscape.

The holiness of the chapel is no stiff solemnity or ceremonialism. It is open receptiveness. The space gives space. Its archaic character makes it a frame for just the essential, a kind of empty space waiting to be filled. One can enter the church with plebeian thoughts in mind, and everyone can bring along their own idea of holiness. The journey back to the everyday through the forecourt compares in significance with watching the view of the altar wall. The wooden fence both opens and closes the sphere of the church.

35

VUOKSENNISKA, IMATRA 1955–58

THE CHURCH OF THE THREE CROSSES | ALVAR AALTO

The white tower of the church in this industrial town has to compete in height with factory chimneys reaching over the treetops. The church at the bottom of the tower, a free-form asymmetrical building in a sparse pine forest, is in striking contrast to the factories. The Church of the three Crosses has many faces. In its versatility, even the ordinary and the festive overlap. The forms and spaces are full of energy. The church can be approached from many directions. To the front part of the church the visitor arrives crosswise from the side of the building and meets the tripartite arrangement of spaces covered by free-form curving vaults, simultaneously separate from each other yet joined together. The play of the vaults is completed by the dynamic rhythm of the fan-shaped clerestory windows. Entering from the end of the building, the visitor meets a baroque sequence of successive pulsating spaces leading to the altar. The strong forms are calmed as they reach the softly curving altar wall with three inclined crosses in the centre. The number three recurs in the church on many levels, in its spaces, forms and details.

The church is a closed space. The only views outside are glimpses of sky through windows placed high on the wall. Light is focussed on the front area and moves around the altar during the day. Before noon, light rays penetrating three skylights hit the crosses of the altar. In the afternoon the image of a thistle window on the west wall reflects in front of the altar, its colour glowing strong in the white coloured space.

< *The coloured shadow of the thistle window falls on the floor in the late afternoon, symbolically at the hour which is said to coincide with the moment Jesus died on the cross. Three rays of light fall on the altar crosses during the sermon.*

KANGASALA 1958–1960

VATIALA CHAPEL | VILJO REVELL

Vatiala Funeral Chapel is situated upon the crest of a pine-clad ridge. It is a sculptural body in the midst of the landscape, acquiring its strength from clear-cut, even austere forms. The high vault of the large chapel dominates the building, accompanied by the heavy horizontal slab-like roof of the small chapel. The building winds inside within its rectangular sphere, almost enclosed from the outside world by the concrete walls.

Entrance to the two chapels is through a simplified, low vestibule. The large chapel with its high vault reminiscent of Gothic forms links it to the long chain of history. The altar wall is stark and silent, dominated by a dark cross. The symmetrical space is powerfully oriented towards the altar. The sturdy, dark, wooden pews seem to challenge gravity, as they appear to float above the floor.

The austerity is juxtaposed by live water. Behind the glass surfaces of the side walls are pools reflecting rays of the sun right up to the vault of the ceiling. Nature is present in the interior as a tacit surface of water or as sparkling sunlight when a breeze ripples the surface. Behind the pools are two different views, one confined to the interior of the building, the other opening to a forest. Exit to the cemetery is very simple: directly through the door in the rear wall.

The small chapel is even more concentrated in its atmosphere. Only a narrow band window surrounds the closed space high up between the wall and the seemingly floating ceiling. The ceiling cladding continues outside as a jointless surface. Vatiala Chapel realises the thought of ripping away all secular distinctions. Bareness is its purifying force.

52

The funerary traffic is directed behind the chapel.

∨ *Small chapel, interior view.*

∨∨ *A view from the large chapel to the exterior pool.*

1958–61

HYVINKÄÄ CHURCH | AARNO RUUSUVUORI

Seen from the main street of the small town of Hyvinkää, the peak of the church rises above the treetops. From the west and north it looks like a perfect pyramid, a completely closed form. Ascending a gentle slope from the south, one finds it is like two tents placed face to face, or like hands clasped in prayer. Its end points touch earth and heaven, and in between is a sheltering space. The building reaches upwards, its arrow-shaped window with a cross pointing to heaven. At the same time it is firmly attached to the ground.

The strong basic form is a counterpoint to the surrounding small wood. The pyramid associates with eternal life. The church has been 'detached' from its setting: moat-like borders surround the closed sides and the entrance sides are a step above the level of the ground.

The building is entered underneath a low hem. The first view of the church interior is seen from the outside, dimly visible behind glass walls and doors, and continuing through a low vestibule. The chancel protrudes from a triangular side as a right-angled fold. It is marked in the interior by the smooth surface of the choir wall at the furthest end of the church. The only views out are through the glass rear wall where the entrance is and through a window by the side of the altar.

The most powerful element in this church is the upward and backward movement of the folded tetrahedral ceiling towards the large, south-oriented top window. Simultaneously the same form pulls the space to the ground and keeps it in place. The underlying principle in the design is the holy number three. The church is defined by mathematics and rationalism, as well as irrational sublimity.

61

TAMPERE 1964–66

KALEVA CHURCH | RAILI AND REIMA PIETILÄ

Kaleva Church is the landmark of a residential area in an industrial city. It is situated on a hillock in an open park at the end of a street coming from the city centre, rising above the plain, rather massive apartment blocks in the neighbourhood. There is air and space around it. It is a church built traditionally in a clearly visible location. Broad steps lead to a front platform. As in old cathedrals, one steps though a small vestibule into a church whose magnitude is awe-inspiring. This space is committed to the heritage of cathedrals. One experiences its live quality when moving, as it unfolds step by step.

There is a strong focus on the altar, emphasised by the gentle slope of the floor. It is as if the altar draws the visitor towards it. There is also tension in another direction, attracting one to walk around and follow the rhythm of the channel-like wall elements. This dynamic space is disconnected from the outside world and at the same time connected with it by the fibrousness of its windows. The views to the outside are of secondary importance. The only message from the outside world is the light pouring in from hidden sources as in baroque churches.

The space invites one to move forward and lift up one's eyes. The immense height elevates a person above everyday pursuits and thoughts. The altar, the focus, also extends its branches high towards the light. The roar of the organ, sound reaching up to heaven, completes the experience of elevation. The power of the Kaleva church is a rare quality in Finnish church architecture. It has the echo of the burning assurance of medieval cathedrals.

Altarpiece Broken Reed, by Reima Pietilä.

Views from the ceremonial chapel.

TAIVALLAHTI, HELSINKI
1968–69

TEMPPELIAUKIO CHURCH | TIMO AND TUOMO SUOMALAINEN

Excavated in the bedrock in the heart of a stone city and closed blocks, Temppeliaukio Church is a world of its own. It is totally separated from the everyday bustle and the tourist buses swarming around it. The place recalls ancient barrows and holy mounds. The only outward sign of a church is a small cross on top of the rock. The archaism arouses a strong primal feeling.

The church is entered through a low, dimly lit vestibule. Feelings of humility and bowing dominate the act of entrance, as into something dark, unknown, even concealed. A church can be a refuge and a shelter. Here, the church is joined to city life only by a narrow cut. The vestibule silences the visitor without revealing what is to come. After a halt the building opens up as a spacious and luminous church interior. Once underground, one can breathe freely under the solar disk that dominates the space. Natural light comes down from a cupola, flowing along the rough surface of the rocky wall. In this church, nature is austere stone, but it is also the water of life dripping from the wall. The space is a single, closed entity, a universe of its own. Rays of light link it to nature and the surrounding world. They are unidirectional, from heaven towards earth. The edge of the gallery draws a cut across the space. The altar rises a few steps above the floor, embraced by the rock. The unassuming altar furnishings submit to its powerful forms. As light filters through roof trusses towards the altar, it resembles the representations of heavenly light in ecclesiastical art.

< *Perspective view, competition proposal.*

$tg\ \alpha = \frac{1}{2}$

Detail section of church wall,
skylight and cupola 1:100

1:2000

TURKU 1965–1967

THE CHAPEL OF THE HOLY CROSS | PEKKA PITKÄNEN

The low, light coloured building of the Chapel of the Holy Cross is situated tucked between a gentle slope opening to the front and a pine-growing ridge rising behind. It is attached to the landscape by long walls and a canopy directing movement and gaze. From under an open canopy the visitor moves into a lobby, the views of the landscape opening through its glass wall. The lobby with its concrete wall surfaces forms a gate to the chapel. As one enters, the space encloses. Dimness prevails in the large chapel interior, where only a faint glimpse of the outside world is present. The visitor is accompanied by light falling on the side wall from a skylight. The simplicity of the harmonious space, which is cut in concrete, is elevating and calming. The focus is on the ray of light falling on the altar and the coffin. Timelessness is emphasised in the severe purity of the space and the simple forms of the altar and pulpit. Material is in a way spiritualised. The building also houses a smaller chapel, which is intimate and more open and luminous in nature. Exit to the cemetery from both chapels is through a yard bordered by a concrete wall.

< *Perspective view from the large chapel, competition proposal.*

91

The symbolism of the open grave is present in the large chapel.

< *Small chapel*

∨ *The urn delivery space is a small
and concentrated, chapel-like room.*

ESPOO 1979–81

OLARI CHURCH | KÄPY AND SIMO PAAVILAINEN

In its dispersed character, the immediate environs of Olari Church are typically Finnish: the foreground consists of street crossings, garages and light industry. Detached from this commonplace chaos, the church borders a hill as a solid redbrick wall and fortress. Between two building volumes is an opening for a passage rising to a churchyard. Here the wall, outwardly high and defensive, changes into low buildings surrounding a park.

The dialogue of closed and open continues in the sequence of interiors. The south side of the church is a protective wall with narrow vertical windows letting in bright beams of light that receive the daytime visitor. The opposite side opens towards the yard through glass walls and the vestibule, and towards heaven through the clerestory windows. These also let in the warm rays of the evening sun. The apse at the extreme end of the longitudinal, slightly bent space is filled with morning light. The cross, on one side, is as if it were hidden. The altar and the cross invite visitors to approach them.

< *Section, in perspective, competition proposal 1:200 .*

1979–83, COLUMBARIUM 1995–98

KAUNIAINEN CHURCH | KRISTIAN GULLICHSEN

The high, closed, gently undulating end façade of Kauniainen Church rises like a castle on a slope, drawn aside from the nearby street. Behind the wall, made of brick and covered with a wooden trellis, the building continues its ascent up the hill. It is like a small village flanked by a street, enclosing a little courtyard in the shelter of its walls.

Along the wall and the street, one finds many reminiscences and references. Intentional cultural references tie the church into a long historical continuum. Fragments from Finnish medieval churches and Le Corbusean buildings have been embedded in the building's whitewashed Mediterranean façades. This rational and cultural path also offers experiences. Arrival rituals have varying characteristics depending on the direction. The church is hidden behind the wall, virtually imperceptible from the outside. The luminous vestibule of the building, opening to the courtyard through a large, curved glass surface, has the feeling of an outdoor space. The church is reached via a dim, descending passage, which recalls the subterranean refuges and catacombs of the early Christian congregations. Partly embedded in the ground, the church opens on one side of the passage. The simple, rectangular space continues the narrative and collage that began with the exterior. A broad altar wall assembles together the principal functions of a church: sermon, liturgy and baptism. The Holy Trinity is represented by three light wells projecting spots of light on a white wall where they move during the day. A triangular skylight prism above the altar lets in light that strikes the altar at the time of the church service. A cut of light above the baptismal font becomes the water of life flowing into the font.

The columbarium, placed at the foot of the church, is an intense interpretation of the primal form of Christian space. A descending passage crosses the River of Tuonela, the underworld, and leads to the urn graves and finally to a rock tomb. A comforting light falls from above on the niche wall. The only sound breaking the prevailing silence comes from the whirling water.

< *Perspective view, competition proposal.*

∨ *The entrance to the columbarium
via the plinth of the club building.*

Interior view of the columbarium. >

Perspective view, competition proposal.

KUOPIO 1989–92

ST. JOHN'S CHURCH MÄNNISTÖ | JUHA LEIVISKÄ

St. John's Church Männistö is situated flanking a suburban housing area. The site is in front of a line of apartment blocks, in fact at a lower level in a hollow. The environment is plain and almost characterless. The church has the task of standing up like a gateway and a local landmark, as if defending the ordinary life behind. The high walls of the bell tower and the church elevate the building above the commonplace, but not oppressively.

The church is entered from the rear through a low vestibule. The spaces and views gradually open up and expand. Standing under the gallery and turning towards the altar one sees the first part of the rhythm of overlapping vertical wall planes. The whole height of the room is not revealed until later. The space is open and closed at the same time, open when light pours in, closed when it comes from a hidden source behind the planes. With every step the space and the lighting change. Views out to nature are replaced by vivid light. Art and architecture are one. The colours glowing on the planes around the altar come to life as they are struck by light, and their reflections are projected on the opposite walls. Light and colour are in continuous interaction; touching each other gently, they fade and brighten alternately.

233 1-3
135
513
236
452
464
510
332

233 1-3
135
513
236
452
464
510
332

The altarpiece by artist Markku Pääkkönen uses indirect reflections of light combined with coloured wall surfaces. The lighting of the church is designed by Juha Leiviskä.

Site plan, proposal 1:1500

Juha Leiviskä's winning entry 'Nisukeko' ('Wheat Stook') was seen to best fulfil the function of a church as a place of silence and communion with God and as a home for the congregation. Besides the church, the building includes rooms for parish offices, clubs and meetings. The competition entry suggested a pool arrangement in front of the church, but for reasons of economy it was reduced to a stone garden during the design phase. The verticality characterising the building comes from the combination of high wall planes and the acute angles of the skylight prisms. The low-rise club buildings accompany the church as a meandering podium. Red brick and white plaster are the materials of the façades.

Ground floor plan 1:700

1 Entrance hall
2 Church hall
3 Sacristy
4 Congregation hall
5 Offices
6 Club rooms

Section 1:700

TURKU 1995

ST. HENRY'S ECUMENICAL CHAPEL | MATTI SANAKSENAHO

On top of a hill is a chapel like a large sculpture, clad in patinated copper. Its form can be thought to resemble that of a ship, an ark that has just beached on dry land, or the Christian symbol of the fish. The building is a refuge. In its bowels one can compose oneself in a safely enclosed space.

Passing through a low lobby, one enters the chapel where wooden walls, articulated by rhythmically repeated ribs, curve softly towards each other to meet at the pointed peak of the ceiling. They are like hands held together to form a shelter. Behind the visitor the gallery forms a silent space lit by the rays of the afternoon sun, which also reach the chapel.

The sidelight illuminating the altar, filtered through a stained glass window, brings a varying play of light and colour to the dimness of the room. The chapel conveys a message of tranquility and simplicity.

Plan and longitudinal section 1:150

1 Main chapel
2 Gallery chapel

> *Model, competition proposal*

>> *Views of the main chapel looking eastwards.*

>>> *A view in the small gallery chapel looking westwards.*

An invited architectural competition for an Ecumenical Chapel, a place of peace common to all Christian churches was organised in 1995. The underlying principle of the winning proposal 'Ikthys' ('Fish') is the fusion of art and architecture.

135

SELECTED INFORMATION

CURRICULUM VITAE – ARCHITECTS AND AUTHORS

ERIK BRYGGMAN
1891–1955
Architect, Helsinki University of Technology (1916),
Professor (honorary) (1948)

Selected Works:
The Atrium apartment building, Turku (1925–27)
Hospits Betel, Turku (1928–29)
Vierumäki Sports Institute, Heinola (1931–36)
Book Tower, Åbo Academy Library, Turku (1934–35)
Main Offices, Sampo Insurance Company, Turku (1937–38)
Turku Castle, restoration (1944–54, 1962)
[Not finished by Bryggman]
Residential buildings for the Turku ship industry,
Pansio (1945–49)
Villa Nuuttila, Kuusisto (1947–49)
Riihimäki water tower (1951–52)

Churches and Other Ecclesiastical Buildings:
Burial Chapel, Parainen (1929–30)
Kakskerta Church, restoration (1939–40)
Chapel of the Resurrection, Turku (1941)
Vasaramäki parish building, Turku (1944–1946)
Burial Chapel, Lohja (1952–56) [Not finished by Bryggman]
Burial Chapel, Honkanummi, Helsinki (1953–56)
[Not finished by Bryggman]
Ristikangas Chapel, Lappeenranta (1955–56)
[Not finished by Bryggman]

Awards:
Honorary member of the Finnish Association of Architects (1955)

HEIKKI SIREN
1918–
Architect, Helsinki University of Technology (1946),
Professor (honorary) (1970)

KAIJA SIREN
1920–2001
Architect, Helsinki University of Technology (1948)

Selected Works:
The National Theatre 'small stage' annexe (1954)
The National Theatre, restoration (1963)
Pirkkola Sports Park, Helsinki (1968–74)
Ympyrätalo office and commercial building, Helsinki (1968)
Housing area, Boussy St. Antoine, Paris, France (1970)
Brucknerhaus Concert Hall, Linz, Austria (1974)
Golf-centre, Onuma, Japan (1976)
Conference Palace, Baghdad, Iraq (1982)

Churches and Other Ecclisiastical Buildings:
Otaniemi Chapel, Espoo (1951–57)
Helsinki Cathedral, restoration [with J. S. Sirén] (1961–63)
Orivesi Church (1961)
Espoo Funeral Chapel (1963)

Awards:
Camillo Sitte Prize, Vienna (1979)
Gold Medal, The French Academy of Architecture (1980)
Member of the French Architecture Academy (1984)
Honorary Fellow, The American Institute of Architects (1986)
Honorable Member, The Finnish Association of Architects (1992)

ALVAR AALTO
1898–1976
Architect, Helsinki University of Technology (1921),
Academician (1955)

Selected Works:
Workers' Club, Jyväskylä (1924)
Paimio Sanatorium (1929–33)
Viipuri City Library (1927–35)
Sunila pulp mill and housing area,
Kotka (1936–39, 1945–47, 1951–54)
Villa Mairea, Noormarkku (1938–39)
Baker House Dormitory, MIT, Cambridge, USA (1946–49)
Muuratsalo 'Experimental House' (1952–54)
Säynätsalo Town Hall (1949–52)
National Pensions Institute, Helsinki (1948–57)
House of Culture, Helsinki (1952–58)
Seinäjoki Town Centre (1956–88) [Not finished by Aalto]
Helsinki University of Technology, Otaniemi, Espoo (1949–74)
Finlandia Hall, Helsinki (1962–75)

Churches and Other Ecclesiastical Buildings:
Toivakka Church, restoration (1923)
Anttola Church, restoration (1924–26)
Viitasaari Church, restoration (1925)
Kemijärvi Church restoration (1925, 1926–29)
Pylkönmäki Church, restoration (1926)
Korpilahti Church, restoration (1925, 1926–27)
Kauhajärvi Church and bell tower (1921–23)
Muurame Church (1926–29)
Seinäjoki Church and Parish Centre
(1951, 1956, 1958–60, 1964–66)
Church of the Three Crosses, Vuoksenniska, Imatra (1956–58)
Church Centre, Wolfsburg, Germany (1960)
Church Centre, Detmerode, Germany (1963, 1965–68)
Church Centre, Riola, Italy (1965–1980) [Not finished by Aalto]
Alajärvi Parish Centre (1966–70)
Lahti Church (1969, 1975–1979) [Not finished by Aalto]

Awards:
Academician in Architecture, Member of the Academy
of Finland (1955)
Gold Medal, The Royal Institute of British Architects (1957)
Honorable Member, The Finnish Association of Architects (1959)
Sonning Prize, Denmark (1962)
Gold Medal, The American Institute of Architects (1963)
Grand Cross of the Order of the Lion of Finland (1965)
Gold Medal, The French Academy of Architecture (1972)

AARNO RUUSUVUORI
1925–1992
Architect, Helsinki University of Technology (1951), Professor

Selected Works:
Weilin & Göös printing works, Espoo (1964–66)
Roihuvuori Primary School, Helsinki (1964–67)
Marimekko printing works, Helsinki (1967)
Police Headquarters, Mikkeli (1968)
Helsinki City Hall, renovation and extension (1960–70, 1988)

Churches and Other Ecclesiastical Buildings:
Hyvinkää Church (1961)
Huutoniemi Church, Vaasa (1964)
Tapiola Church, Espoo (1963–65)
Rauhanummi Chapel (1972)

Awards:
Professor of Arts (1978–83)
Honorary Fellow, The American Institute of Architects (1982)
Order of the Lion of Finland – Commander
Finnish State Prize for Architecture and Community Planning (1985)
Pro Sculptura Medal

VILJO REVELL
1910–1964
Architect, Helsinki University of Technology (1936)

Selected Works:
'Glass Palace', Helsinki (1935–36) [with Niilo Kokko and Heimo Riihimäki]
Vocational College for war veterans, Liperi (1946–49)
Palace Industry Centre, Helsinki (1949–53) [with Keijo Petäjä]
Meilahti Primary School, Helsinki (1950–53) [with Osmo Sipari]
Several housing projects in Tapiola Garden City, Espoo (1952–61)
Kudeneule factory, Hanko (1953–56)
Toronto City Hall, Canada (1958–63)
Town Centre block, Vaasa (1962)

Churches and Other Ecclesiastical Buildings:
Vatiala Chapel, Tampere (1957)

Awards:
Order of the Cross of Liberty – 4th Class

REIMA PIETILÄ
1923–93
Architect, Helsinki University of Technology (1953), Professor, Academician (1982)

RAILI PIETILÄ
1926–
Architect, Helsinki University of Technology (1956)

Selected Works:
Finnish Pavilion, Brussels World Fair (1956–58)
Suvikumpu housing area, Espoo (1962–69, 1979–83)
Dipoli Students Union building, Otaniemi, Espoo (1961–66)
Finnish Embassy, New Delhi, India (1963, 1980–85)
Sief Palace buildings, Kuwait (1973–82)
Metso, Tampere Main Library (1978–85)
Mäntyniemi, Official Residence of the President of Finland, Helsinki (1984–87)

Churches and Other Ecclesiastical Buildings:
Kaleva Church, Tampere (1964–1966)
Lieksa Church (1979–84)
Hervanta Parish Hall, Tampere (1979)

Awards:
Reima Pietilä:
Honorary member of the Swedish Royal Academy of Liberal Arts (1969)
Professor of Arts (1971–74)
Honorable member, Finnish Association of Architects (1975)
Honorary Fellow, American Institute of Architects (1976)
Tapiola Medal (1981)
Prins Eugens Medal, Sweden (1981)
Academician in Architecture, Member of the Academy of Finland (1982)
Honorary member, Federal Association of West-German Architects (1983)
Raili Pietilä:
Honorary Fellow, American Institute of Architects (1996)
Honorable member, The Finnish Association of Architects (2002)

TIMO SUOMALAINEN
1928–
Architect, Helsinki University of Technology (1956)

TUOMO SUOMALAINEN
1931–1988
Architect, Helsinki University of Technology (1960)

Selected Works:
Keuruu Military Centre (1960, 1963–91)
Haaga Vocational School, Helsinki (1962–67)
Hotel Mesikämmen, Ähtäri (1973–76)
Hamina Police Station and Law Courts (1979–84)
Espoo Commercial College / Laurea Polytechnic, Espoo, extension (1998, 2000–2002) [Timo Suomalainen]

Churches and Other Ecclesiastical Buildings:
Temppeliaukio Church, Helsinki (1960–1969)
Ristiniemi Chapel, Hamina (1962–65)
Espoonlahti Church, Espoo (1976–80)
Leirikangas Chapel, Vehkalahti (1986–89)
Kellonummi Chapel, Espoo (1986, 1992–93)
Paijala Chapel, Tuusula (1991–93) [Timo Suomalainen]
Hietama village church, Äänekoski (1994, 1996–97) [Timo and Ilari Suomalainen]
Pornainen Parish Centre (1998, 1999-2000) [Timo and Ilari Suomalainen]

Awards:
Diploma and Silver Hexagon of Habitation Space [International Award, Milan] (1978)

Uusi Suomi Milieu Award (1984)
IFRAA (International Architectural Design Awards)
Honor Award, USA (1992)
Order of the White Rose of Finland - Knight 1st Class (1976)
[Timo Suomalainen]
Honorary Fellow, American Institute of Architects (2000)
[Timo Suomalainen]
Espoo City Cultural Prize (2002) [Timo Suomalainen]

PEKKA PITKÄNEN
1927–
Architect, Helsinki University of Technology (1953), Professor

Selected works:
Parliament House Extension, Helsinki (1978)
Turku Court House (1997)

Churches and Other Ecclesiastical Buildings:
The Chapel of the Holy Cross, Turku (1967)
Parish Centre, Säkylä (1968)
Parish Centre, Kurikka (1969)
Turku Christian Institute (1974)
Turku Cathedral, renovation (1979)
[Pitkänen-Laiho-Pulkkinen Architects]
Harjavalta Church (1984)

Awards:
State Award for Building and Community Planning (1982)

SIMO PAAVILAINEN
1944–
Architect, Helsinki University of Technology (1975), Professor

KÄPY PAAVILAINEN
1947–
Architect, Helsinki University of Technology (1975)

Selected works:
Mansikkala office and business facilities, Imatra (1986–90)
Vaasa University (1985–94)
Finnish Embassy, Tallinn, Estonia, renovation (1996)
Tritonia Science Library, Vaasa University (2001)
The Local Government Pensions Institution Offices, Helsinki (2003)

Churches and Other Ecclesiastical Buildings:
Olari Church and Parish Hall (1976–1981)
Paimio New Parish Hall (1984)
Kontula Church, Helsinki (1988)
Pirkkala Church and Parish Hall, Pirkkala 1994
Helsinki Parish Cemetry, extension and urn grave (1996)
Vehkalahti Parish Hall, Hamina (2002)

Awards:
Culture prize, The Finnish Cultural League (1983)
[Simo Paavilainen]
Tiili magazine Award for Architecture (1983)
Finnish State Prize for Architecture and Community Planning 1991

National Board of Building Annual Building Award
[Vaasa University, Stage 1] (1994)
SIO Interior-Design Award (1998) [with Lauri Olin]
Senate Properties Annual Building Award
[Tritonia Science Library] (2001)

KRISTIAN GULLICHSEN
1931–
Architect, Helsinki University of Technology (1960),
Professor (honorary) (1986)

Selected works:
Moduli, holiday house prefabrication system (1970)
[with Juhani Pallasmaa]
Art Museum, Pori (1981) [Gullichsen-Kairamo-Vormala]
Civic Centre, Pieksämäki, (1989) [Gullichsen-Kairamo-Vormala]
Stockmann Department Store, Helsinki (1989)
[Gullichsen-Kairamo-Vormala]
Finnish Embassy, Stockholm, Sweden (2002)
[Gullichsen-Vormala]
University Library, Lleida, Spain (2003) [Gullichsen-Vormala]

Churches and Other Ecclesiastical Buildings:
Malmi Church, Helsinki (1981) [Gullichsen-Kairamo-Vormala]
Church Centre, Kauniainen (1983) [Gullichsen-Kairamo-Vormala]

Awards:
Finnish State Award of Architecture (1978)
Professor Honoris Causa (1986)
Professor of Arts (1988–1993)
Urban Environment Award (1989)
Annual Concrete Construction Award (1990)

JUHA LEIVISKÄ
1936–
Architect, Helsinki University of Technology (1963),
Academician (1997–)

Selected works:
Kouvola Town Hall (1964–68) [with Bertel Saarnio]
The Old Student House, restoration and annexe, Helsinki
(1978–80) [with Vilhelm Helander]
Vallila Branch Library and Kindergarten, Helsinki (1984–91)
[with Asta Björklund]
Auroranlinna housing, Helsinki (1985–90) [with Pekka Kivisalo]
German Embassy, Helsinki (1986–93) [with Rosemarie
Schnitzler and Nicholas Mayow]
Dar al-Kalima Academy, Hall and restaurant building,
Bethlehem, Palestine (1998–2003) [with Jari Heikkinen]

Churches and Other Ecclesiastical Buildings:
Lemi Church, restoration (1967–69)
Nakkila Parish Hall (1968–70)
Puolivälinkangas Church and Parish Centre, Oulu (1971–75)
Myyrmäki Church and Parish Centre, Vantaa (1980–84)
[with Pekka Kivisalo]

Kirkkonummi Parish Centre (1981–84)
St. John's Church, Männistö, Kuopio (1993)
Harju Chapel, restoration and extension, Mikkeli (1995–97)
[with Rosemarie Schnitzler]
Pakila Church, extension, Helsinki (1997–2002)
[with Pekka Kivisalo]
The German Church, Parish Hall refurbishment and annexe, Helsinki (1998–2000) [with Rosemarie Schnitzler]

Awards:
Order of the Lion of Finland, First Class (1979)
Finnish State Prize for Architecture and Community Planning (1982)
Invited member of the Royal Swedish Academy of Fine Arts (1991)
Pro Finlandia Medal (1992)
Professor of Arts (1993–98)
Prins Eugens Medal, Sweden (1994)
Honorary Fellow, American Institute of Architects (1994)
Carlsberg Architectural Prize (1995)
Academician in Architecture, Member of the Academy of Finland (1997)
Honorable member, The Finnish Association of Architects (2002)
Henrik-Steffens-Prize of the Alfred-Toepfer-Foundation (2003)

MATTI SANAKSENAHO
1966–
Architect, Helsinki University of Technology (1993)

Selected works:
Finnish Pavilion, Seville World Fair (1992) [with Monark]
Students' House, Vaasa (1994–99) [with Pirjo Sanaksenaho]
House Tammimäki, Espoo (2001) [with Pirjo Sanaksenaho]

Churches and Other Ecclesiastical Buildings:
St. Henry's Ecumenical Chapel, Turku (1995–)

Awards:
Finnish State Prize for Architecture and Community Planning (1992) [with Monark]
Reima Pietilä Award 2000

FRED THOMPSON
M. Arch. University of Toronto, Canada (1969)
Professor Emeritus of Architecture, University of Waterloo, Canada

Fred Thompson has made extensive study of the relationship between ritual and space, particularly in Japanese culture. He has further studied the relation of these issues in Japanese culture and Western notions of space. In addition to numerous articles on this subject, he also has published the work Ritual and Space (1988) and a pivotal thesis 'A Comparison between Japanese Exterior Space and Western Commonplace' (1988). Thompson has been a visiting professor at various schools of architecture, including: Helsinki University of Technology, Finland; Columbia University Graduate School of Architecture, Planning and Preservation, New York, USA; the Royal Institute of Technology, Stockholm, Sweden, and the Danish Academy of Fine Arts. He worked in the office of Kiyonori Kikutake from 1961 to 1964 and in the office of Prof. Aarno Ruusuvuori from 1965 to 1968.

JARI JETSONEN
1958–
Kouvola College of Art (1978)

Architectural photographer and artisan Jari Jetsonen has been involved with Finnish architecture from various aspects, as a photographer, writer and model-builder. The scale models of Alvar Aalto's and Juha Leiviskä's churches and the competition entry of Matti Sanaksenaho's chapel featured in Sacral Spaces were built by him. Jetsonen has taught at Helsinki University of Technology (1986-1999) and at Nihon University in Tokyo (2000). He took the photographs for the following exhibitions and their accompanying books: "Alvar Aalto Houses" (Alvar Aalto Museum, Jyväskylä / A+U Extra Edition, Tokyo, 1998); Sauna – Furo – Inipi, Bathing on Three Continents (Finnish Sauna Society / Rakennustieto, Helsinki, 2000); Little Big Houses. Working with Architectural Models (Rakennustieto, Helsinki, 2001).

SIRKKALIISA JETSONEN
1958–
Architect, Helsinki University of Technology (1986)

Sirkkaliisa Jetsonen is a researcher who has specialised in post-war Finnish architecture. She has written articles on this subject for a number of publications, among others "Realism or Dreams - Public Buildings in the 1950s" in Heroism and the Everyday. Building Finland in the 1950s (Museum of Finnish Architecture, Helsinki, 1994) and "Human Rationalism - Themes in Finnish Architecture in the 1950s" in 20th-Century Architecture: Finland (Museum of Finnish Architecture, Helsinki / Deutsches Arkitektur-Museum, Frankfurt am Main, Prestel Verlag, Münich, London, New York, 2000). Jetsonen teaches at Helsinki University of Technology and the University of Art and Design Helsinki. She was the coordinator and curator for the exhibition "Outlining Architecture. The Finnish Architectural Review Centenary 1903–2003".

THE ARCHITECT JUDGES ON THE JURYS OF THE COMPETITIONS

The Resurrection Chapel
Uno Ullberg and Eino Sutinen
Otaniemi Chapel
Aulis Blomstedt and Markus Tavio
Hyvinkää Church
Ahti Korhonen and Osmo Sipari
Kaleva Church
Nils Erik Wickberg and Aulis Blomstedt
Temppeliaukio Church
Aulis Blomstedt and Heikki Castrén
The Chapel of the Holy Cross
Aarne Ehojoki and Helmer Stenros
Olari Church
Juha Leiviskä and Timo Penttilä
Kauniainen Church
Timo Penttilä
St. John's Church Männistö
Heikki Taskinen
St. Henry's Ecumenical Chapel
Mikko Heikkinen

SOURCES

The Resurrection Chapel
Finnish Architectural Review Arkkitehti 11–12/1939, 7–8/1942
Janey Bennett, Sub specie aeternitatis. Erik Bryggman's Resurrection Chapel. Erik Bryggman 1891–1955. Arkkitehti arkitekt architect. Ed. Riitta Nikula. Monographs by Museum of Finnish Architecture, Helsinki 1991.

Otaniemi Chapel
Finnish Architectural Review Arkkitehti 11/1954, 6–7/1958

Vuoksenniska Church
Finnish Architectural Review Arkkitehti 12/1959

Vatiala Chapel
Finnish Architectural Review Arkkitehti 5/1962
Viljo Revell. Rakennuksia ja suunnitelmia. Byggnadsverk och projekt. Toim. Kyösti Ålander. Otava, Helsinki 1966.

Hyvinkää Church
Finnish Architectural Review Arkkitehti 9/1961
Aarno Ruusuvuori. Structure is the Key to Beauty. Järjestys on kauneuden avain. Eds. Marja-Riitta Norri, Maija Kärkkäinen. Museum of Finnish Architecture, Helsinki 1992.

Kaleva Church
Finnish Architectural Review Arkkitehti 2/1959 Competition appendix, Finnish Architectural Review Arkkitehti 11–12/1966

Temppeliaukio Church
Finnish Architectural Review Arkkitehti 4–5/1961 Competition appendix 2, Finnish Architectural Review Arkkitehti 4/1970
The Chapel of the Holy Cross
Finnish Architectural Review Arkkitehti 5/1967, 2/1969

Olari Church
Finnish Architectural Review Arkkitehti Competition appendix 2/1977, Finnish Architectural Review Arkkitehti 2/1980, 5/1981

Kauniainen Church
Finnish Architectural Review Arkkitehti 2/1980, 7/1984, 5/1999

St. John's Church Männistö
Finnish Architectural Review Arkkitehti 2/1993
A + U Architecture and Urbanism 1995:04

St. Henry's Ecumenical Chapel
A + U Architecture and Urbanism 1997:04

SOURCES OF ILLUSTRATIONS

Sirkkaliisa Jetsonen: 7 (Petäjävesi Church),
8 (Pampulha Church), 9, 13
Janne Ahlin, Sigurd Lewerentz arkitekt. Byggförlaget, Stockholm 1983: 12 (plan on the right)
Museum of Finnish Architecture: 14, 28, 29
(model photo, Oy Foto Ab), 30, 37 (model photo, Photo Pietinen), 50, 56, 57 (model photo, Heikki Havas), 58, 64, 65
(model photo, Heikki Havas), 75 (model photo, Photo Pietinen), 86, 96 (plan), 97, 135 (perspective drawing, site plan)
Architects Kaija and Heikki Siren: 36, 37
(photo on the right, Esko Silvanto)
Alvar Aalto Museum: 38, 48, 49 (plan)
Architects Raili and Reima Pietilä: 66, 74, 75
(section, photo on the right, Raili Pietilä)
Finnish Architectural Review 4–5/1961:76
Finnish Architectural Review 7/1984: 106, 116, 117 (plan)
Architects Suomalainen: 82, 84
(photo on the right Tapani Leppälä), 85 (plan)
Architect Pekka Pitkänen: 96 (photos Ola Laiho)
Architects Käpy and Simo Paavilainen: 98, 104, 105
(model photo Henrik Kråkström)
Architect Juha Leiviskä: 118, 128, 129 (plan and section)
Architect Matti Sanaksenaho: 130, 131, 132, 133, 134 (facade)

1 ESPOO
Olari Church
Otaniemi Chapel

2 HELSINKI
Temppeliaukio Church

3 HYVINKÄÄ
Hyvinkää Church

4 IMATRA
The Church of the Three Crosses

5 KANGASALA
Vatiala Chapel

6 KAUNIAINEN
Kauniainen Church

7 KUOPIO
St. John's Church Männistö

8 TAMPERE
Kaleva Church

9 TURKU
The Chapel of the Holy Cross
The Resurrection Chapel

EPILOGUE

This book and the accompanying exhibition began in the spring of 2002 when both my mother and father were seriously ill. My mother died. Soon afterwards I found myself almost every day in churches, looking at the spaces and getting a sense of their spirit as best as one can through the lens of a camera. I had some other on-going projects at that time, but somehow the 'church project' started to become very important to me, and I ended up spending the whole summer on it. In July 2002 I travelled to Tokyo for the opening of the Alvar Aalto Houses exhibition. While I was there I showed some of my church photographs to the director of the Tokyo Design Center, Coco Funabiki, and she said that they would like to arrange an exhibition of the photographs at the Center. I have now been photographing the selected churches and chapels for over one year, and I can see how the atmosphere in the photographs has changed. The first photographs were very dark and devoid of people, but in the more recent ones, taken in spring 2003, I became more aware of light, as well as people using the church, from weddings to funerals. With these photographs, I dedicate this book to the memory of my mother, Hilda.

Helsinki 6.7.2003
Jari Jetsonen